T0000449

KAWS

HANDBOOK

text by

CARLO McCORMICK

edited by

LARRY WARSH

Published by No More Rulers

nomorerulers.com @nomorerulers

NO MORE RULERS ®

The NO MORE RULERS mark and logo are
registered trademarks of No More Rulers, Inc.

All Rights Reserved

ISBN 979-8-9889286-1-4

Design by Hannah Alderfer, HHAdesign

This book has been composed in Helvetica Neue Pro

Printed on acid-free paper

CONTENTS

FOREWORD

KAWS is a true artist of our time, and a formative force in the world of art and popular culture. The contemporaneity of KAWS's oeuvre is, in its own way, ironic. There is little doubt that his work is extremely *of the moment*, and yet, the myriad sources from which he draws are squarely historical. But that in-the-momentness is precisely his ability to draw from the vast field of popular culture and the public imagination, and to retool his references into something both entirely new and yet immediately recognizable. He holds in balance the familiarity of so many cultural touchstones with the generative amalgamation that is his artistic practice. (Simply think of his formative *KIMPSON* characters, his *KURFS*, and *KAWSBOB*. It's all right there, present in his characters and the ways that we receive them.)

KAWS's collaborative relationship with culture, the inventive ways in which he references and repurposes pop icons, can be traced back to his early interventions, his street art, and later to his artistic alterations of advertising. Interestingly, it is in the ad work where we see a crucial turning point: To make these works KAWS had to physically remove a piece of tangible culture, take it back to the studio for intervention, and then physically return the piece, allowing the artwork to be activated by the public

gaze. Whereas in works like the KIMPSON paintings and other series, that which is being referenced is pulled straight from the memory and imagination of the viewer. The physicality of the referent has been sidestepped in a truly brilliant move.

KAWS is a master of referentiality, and his work participates in a long, rich history of art, popular culture, mass media, consumerism, and fashion, as well as craft. Perhaps another way to describe KAWS's practice: post-postmodern. His work is a heightening of remix culture, polishing and perfecting the impulse and execution of mixing and matching: of playing with culture; of making something entirely new through a conscious nod toward the past. His characters are pulled from their syndicated narratives, modified, and repurposed as singular form. (He even cannibalizes his own ever-expanding family of figures.) KAWS has a fundamental grasp on value and marketability, on fan culture and its voracious appetite. Evidenced in the work (and especially so in the toys and package pieces), is his thoughtful understanding of the convivial aspect of fan culture—of the sneaker heads who for fun, hang with their friends overnight outside boutiques, and only in part for a chance at limited-edition kicks. He has successfully created a bridge between the material-culture wants and desires of hip young people, and the exclusive, highbrow world of museums, art collectors, and the market. He has become a role model to others while

also helping to direct culture through his own act of collecting. KAWS understands connoisseurship and the mentality of the collector, as is demonstrated by his package paintings and product designs. Through his practice, he has managed to elevate the seemingly low without debasing the value-laden high.

My goal in creating this handbook is to offer a guide to the world of KAWS, both to provide a map for new audiences to navigate the complexities of his artistry, and to deepen the understanding of those already familiar with his work. KAWS's great accomplishment, and what has drawn me to his work for so many years, is that he hasn't created a movement out of whole cloth. Instead, he has planted himself and his vision within popular culture. He has germinated and cultivated that vision, all the while pushing culture forward and gently encouraging us to join him. And, he is able to do so (in no small part) precisely through his play with reference and familiarity. KAWS has made himself an ambassador of the now.

Larry Warsh
New York City
September 2023

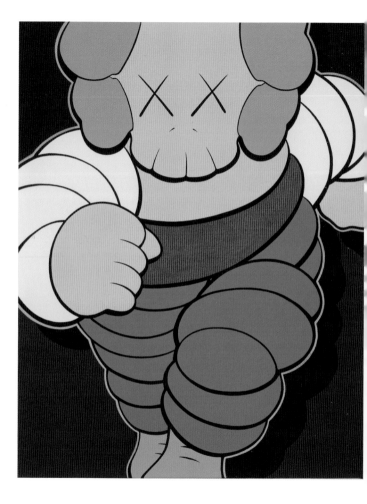

HK CHUM, 2002, acrylic on canvas over panel,
20 × 16 inches (50.8 cm × 40.6 cm)

INTRODUCTION: KAWSMOLOGY

Prolific and populist, the sheer volume and variety of KAWS's oeuvre can be a bit overwhelming for the uninitiated viewer. How do we differentiate between the paintings and the products, or the monumental public sculptures and the intimate, soft vinyl figurines; or for that matter, make sense of the seemingly infinite array of KAWS's nontraditional art objects, from skateboards to T-shirts to all manner of apparel and novelties, and especially when encountered within an art museum context? And when the artist-designer collaborates with corporations and multinational brands, how do we recognize their hand in the productive process? Where does the impermanence of his work on the street, or the immateriality of his virtual reality works fit in with the physicality and historical durability of fine art? Indeed, when something is so fresh and of its time, it's sometimes difficult to imagine its place in the timelessness of culture.

KAWS's art represents a major paradigm shift in our culture, and to understand it we need to make a similarly dramatic shift in our understanding of art in general. The key to comprehending the totality of his vision is to recognize that while all of the various components of his creative output are discretely individuated, they all originate from a single source. The answer to this may be very simple: They are all connected and essentially one and the same—the explanation, however, for why this is the case is rather more complex. KAWS arrives in our public imaginary at a time when the usual distinctions we make between art and design, creativity and commerce, the handmade and the mass-produced (or even the commonplace and the extraordinary), have largely dissolved into the whirling global stream of rapid, ever-evolving interconnectivity that we call visual culture. As a maker of things—crafts-person, designer, producer, self-invented brand unto himself—KAWS is an exemplary example of the widespread convergence underway in all forms of cultural and self-expression. But as an artist of prodigious acumen seemingly always a few steps ahead of the rest of us, he is a radical change agent.

In many ways the need to explain KAWS at all is a kind of cross-generational conversation. If you are young enough to have grown up in the digital age, and conscious of (and open to) the myriad ways in which personal identity can be constructed and

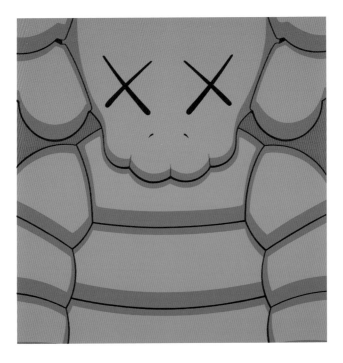

conveyed through our choices as consumers; if you are accepting of the fact that desire and understanding are not merely a set of personal emotions or ideations, but algorithms recognized and reified in a new collective consciousness; well, then the very idea that this heterogeneous collection of disparate elements is somehow impossibly interconnected and equivalent is a lot easier to fathom than it might be for older generations, those who may still cling to hierarchical thinking and the rigid stratification of high culture and low culture.

NEW TURN, 2020, acrylic on canvas, 70 x 70 inches (177.8 x 177.8 cm)

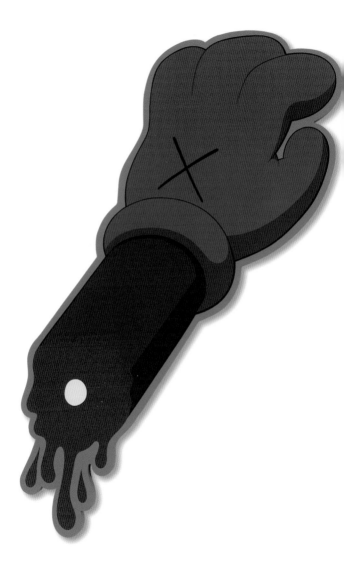

NIGHT LESSON, 2012, acrylic on canvas over panel, two parts.
Each part: 72 × 45 inches (183 × 114.3 cm)

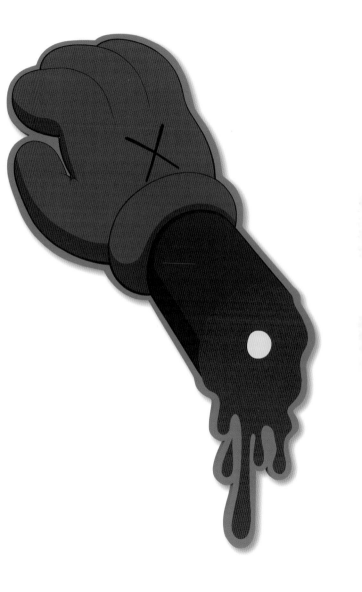

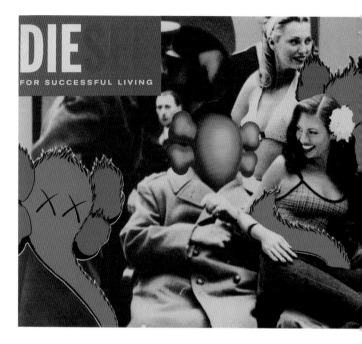

Often, when we hear the gatekeepers of fine art bemoan KAWS and his phenomenal popularity as a symptom of the dumbing down and crass commercialism of culture, it's hard not to write them off as clueless fuddy-duddies. Living in an age of instantaneity and interchange, KAWS is himself extremely patient. He's been untimely for so long that he's not in a rush, and, he knows that the slow machinations of institutional ratification will inevitably catch up, and as his fans, we too benefit from a little KAWSian patience. Having been an early arrival to his work

UNTITLED (DIESEL), 1998, acrylic on existing advertising poster mounted on wood panel, 56 × 138 inches (142.2 × 350.5 cm)

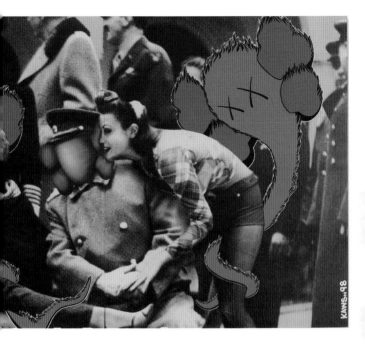

and a longstanding supporter, even I have not always entirely gotten it. I remember the time I saw the early COMPANION statues. How, when I asked him about this new turn to sculpture he looked at me quizzically, as one might to a slightly dim-witted older brother, and explained that he had been making sculptures for a very long time. Of course, to his mind his toys were sculptures; it's just that now, in a different context, at a different scale and price point, it is our perception of them has changed. To be a follower of KAWS—and judging by his social media

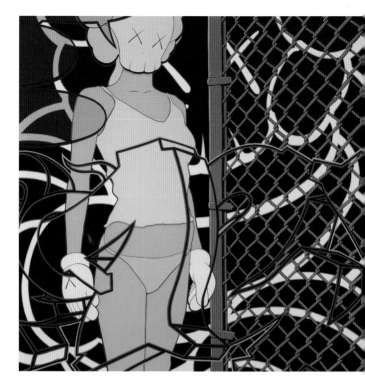

profile he has millions by now—literally means to follow his work with the presumption that he remains untimely, and will continue to take us to new and unexpected places. The *KAWS Handbook* aims to do precisely this, to follow KAWS from his modest beginnings, through the various stages his global ascendance, and just as importantly to examine the individual aspects of his life and work so as to understand the connections that make them whole.

UNTITLED (ORANGE FENCE), 2002, acrylic on canvas over panel, 58 × 58 inches (147.3 × 147.3 cm)

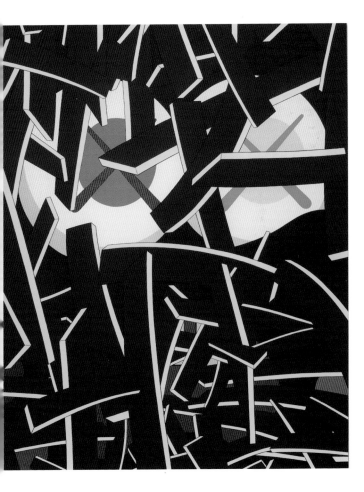

GLASS SMILE, 2012, acrylic on canvas,
120 × 96 inches (304.8 × 243.8 cm)

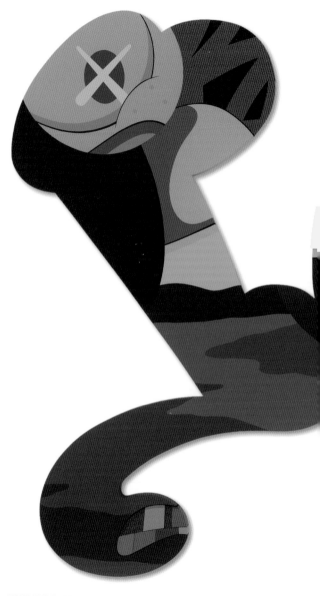

TAKE THE CURE, 2013, acrylic on canvas,
97 × 120 inches (246.4 × 304.8 cm)

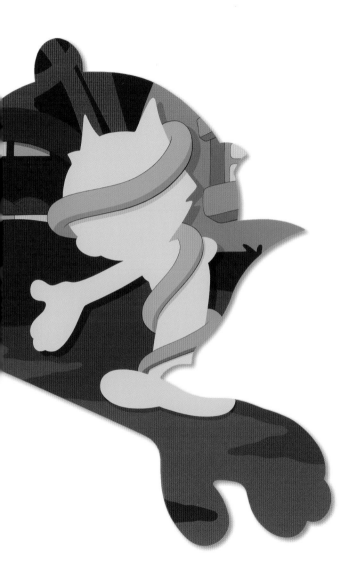

HOLIDAY (2), 2020, aluminum, paint,
$21^{11}/_{16}$ × $28^{15}/_{16}$ × $22^{13}/_{16}$ inches (55 × 72 × 58 cm)

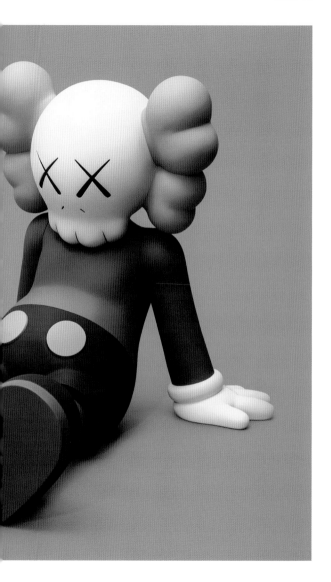

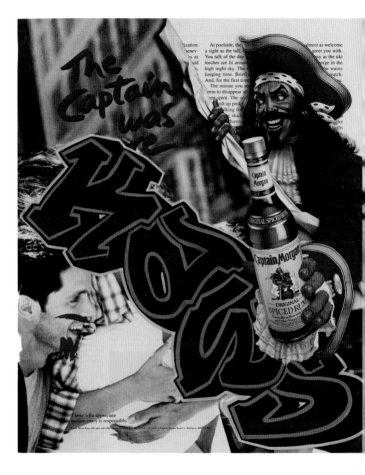

THE CAPTAIN, 1995, paint marker on existing magazine advertisement,
12 × 10 inches (30.5 × 25.4 cm)

WHO IS KAWS?

An international art star, a major collector of contemporary art, a popular designer, a husband and father, a businessperson and a brand: But who is KAWS? Perhaps because the real person in the real world is never quite as exciting as the enigma of their public persona, or maybe because in his case he's actually a rather shy and private person, we all tend to focus less on who Brian Donnelly is than on his larger-than-life image as KAWS. But of course, they are inseparable. And while the art matters most of all, the artist's biography is just as essential.

Donnelly was born on November 4, 1974, in Jersey City, New Jersey. Still large and densely populated by the time young Donnelly came around, Jersey City was like many old port and manufacturing towns at the time—that is, not as prosperous or desirable a place to be in the decades following World War II, as both shipping and manufacturing saw a rapid decline. Directly across the Hudson River from the fabled island of Manhattan, and long considered part of the greater New York metropolitan area, by the 1980s Jersey City could be considered pretty boring, utterly normal, and slightly down on its luck. It's not hard to imagine how, as a kid, Donnelly might have looked out at the big city across the river and dream of one day being there instead. Through the youth subcultures

of skateboarding and graffiti that formed his identity and worldview early on, Donnelly—or KAWS as he was already known through his work as a graffiti artist—made his first forays into the heady downtown scene of the late 1980s and '90s to skate the legendary spots; hit the clubs where new music, styles, and ideas were being minted on a nightly basis; and make his mark as an artist. Soon thereafter he made the move, enrolling in the legendary School of Visual Arts (SVA) where many of his childhood heroes, such as Keith Haring, had studied.

KAWS was already fluent in the visual language of alternative youth culture (i.e., of logos, stickers, skateboard graphics, street wear, and the letter styling of graffiti artists) and a versatile artist in his own right. SVA offered him the technical skills and design mastery to take it all to the next level. However, as nearly everyone who has gone to school can testify, what you learn in the classroom is rarely as important to your life as what you learn outside the classroom, and

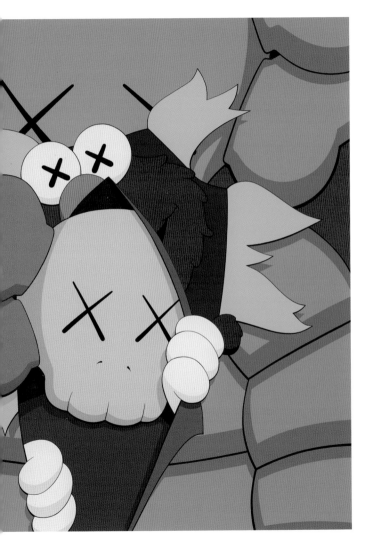

NEW TURN, 2020, acrylic on canvas,
70 × 70 inches (177.8 × 177.8 cm)

it was in New York City, with its somewhat lawless and iconoclastic underground community of creative personalities that much of the subversive strategies, social ethos, and lifelong friendships that define the KAWS of today were forged. Following his graduation from SVA, a brief stint at the animation house Jumbo Pictures (creators of popular cartoons such as *Doug*, and just then shifting from an independent studio to a subsidiary of the mighty Disney empire) brought an invaluable new technique to KAWS's artistic tool chest.

Adapting the skills of animation celluloid painting from his day job to his nocturnal passions as a graffiti artist, KAWS began to alter advertisements found at bus stops and phone booths in ways that were as seamless and seductive as the ads themselves. Arriving at the very moment when a new generation of artists, from Shepard Fairey to Banksy, were beginning to define the nascent movement we now call street art, the immediate success of this new, street-based, illegal public work launched KAWS's early career. For all the promise his innovative approach, transforming the belligerent-mark making of graffiti art (which most people still considered an ugly kind of vandalism), into a relatable, sensual pictorial language, few in this underground scene could have guessed just how far his art and ideas would evolve. The rest, as they say, is history.

COMPANION (OPEN EDITION), 2016, vinyl, paint, 11 x 4.75 x 2.75 inches (28 x 12 x 7 cm)

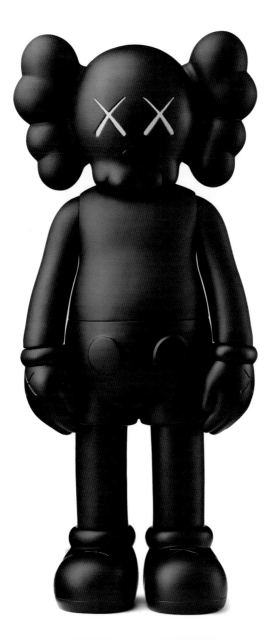

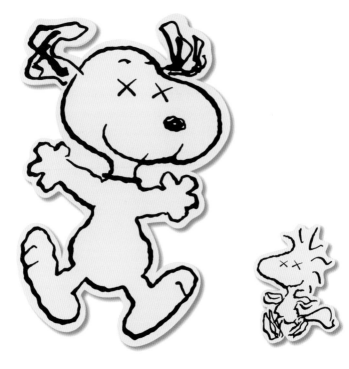

UNTITLED (MBFB9), 2014, acrylic on canvas, two parts.
Part 1: 84 × 48 inches (213.4 × 121.9 cm); Part 2: 30 × 22 inches (76.2 × 55.9 cm)

WE ARE WHAT WE CONSUME

Even the most radical and unexpected artistic innovations do not simply materialize out of nowhere so much as they are, in a way, already present in the culture. They are novelties based on precedence, quintessential expressions of the zeitgeist. KAWS's tenure in the mix of youthful styles that erupted out of Generation X, his deep study of the pop cultural and underground art scenes that informed his generation, and his commitment to collecting and preserving a lineage of artists who make up the unofficial history of these sensibilities, ground his contemporary and progressive aesthetics in a rich sense of legacy. To become a master one must begin as a student. Knowledge is power and context is everything. For the many artists who inspired KAWS along the way and have witnessed how he came to eclipse in fame and fortune the world from which he came, there is this feeling that somehow he charted a map of every step and misstep those pioneers and forerunners before him made and forged a new path forward—a more direct route through the forest of signs toward a perfectly distillate visual language.

The importance of Pop art in opening up the range of imagery allowed to be a significant part of high art, and in the introduction of serial image-making within painting, has been an elemental building block in KAWS's development. With Roy Lichtenstein we

get a sense of permission to appropriate and alter comics-based iconography, which KAWS has freely employed in his own visual interpretations of characters from *The Simpsons, The Smurfs,* Disney animations, and so forth. Similarly we can feel the presence of Claes Oldenburg's large soft sculptures in the billowing, cuddly form of KAWS's

IN THE WOODS, 2002, acrylic on canvas over panel, three parts, 58 × 108 inches (147.3 × 274.3 cm)

monumental Companion statues, and the now distant echo of the artists (Keith Haring among them) who created whole stores of everyday objects as artist-made replicas in the aesthetic product culture of which KAWS is such a central figure today.

For all the ways in which Pop, as a movement with many artists, sensibilities, and scenes around the world, mixed the vernacular with virtuosity, and the commercial with the avant-garde, blending and blurring its high-low ingredients into a heady brew, few of its major figures have cast quite the same spell on later generations as Andy Warhol. If not directly alluded to in KAWS's work, Warhol's embodiment of Pop art as a position of emotional distance, irony, and cool—partly as a hip sensibility, but more crucially as a sharp departure from the hot qualities of Pop's immediate predecessor, Abstract Expressionism—has continued to inform artists as they navigate our contemporary universe of stimulus overload.

Perhaps a more direct and chronologically proximate set of inspirations for KAWS are those artists who pioneered their own Pop art ideas and methodologies—in particular Keith Haring and a generation of artists who emerged in New York City, including Kenny Scharf, as well as the great Japanese artist Takashi Murakami who, with his company KaiKai Kiki, similarly came to define and promote a generation of artists in Japan. Haring's career took off just across the river from KAWS's hometown of Jersey City and exploded worldwide during KAWS's childhood. As such, he would have both a direct and indirect impact on KAWS's work; directly influential as KAWS got to know Haring's work over time, but perhaps already directing

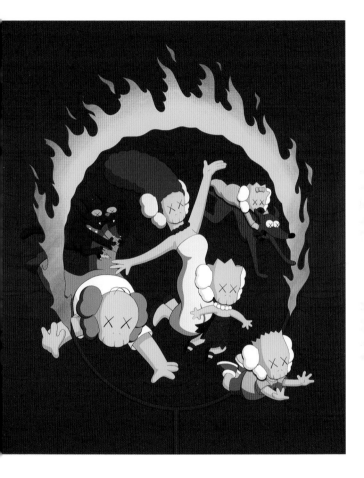

UNTITLED (KIMPSONS), 2004, acrylic on canvas,
60 × 50 inches (152.4 × 127 cm)

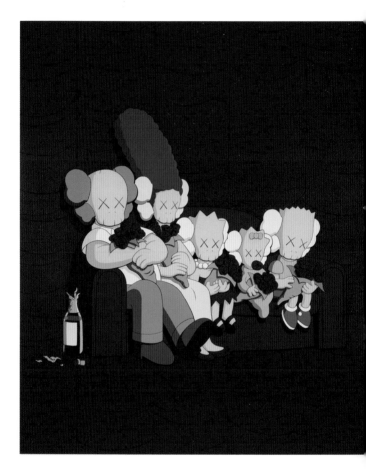

UNTITLED (KIMPSONS), 2004, acrylic on canvas,
60 × 50 inches (152.4 × 127 cm)

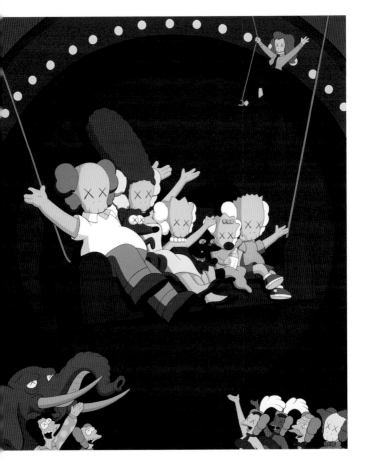

UNTITLED (KIMPSONS), 2004, acrylic on canvas,
60 × 50 inches (152.4 × 127 cm)

street culture through the general osmosis of Haring's perspective—particularly art's role in society, and how that imbued urban art with a broadened sense of possibility. The lessons of Haring's brief career, much like those of his friend Jean-Michel Basquiat, expand and exert influence over time, and from Haring we get both the presentation of a new iconographic language meant to be readable and relatable to those who may never visit a museum, and an even more populist tendency in his mass production of accessible and affordable objects: from the T-shirts and posters to stickers and magnets that Haring sold in his New York and Tokyo Pop Shops.

Murakami, emerging in KAWS's consciousness when he was already a practicing artist, would push Haring's terms of mass engagement even further, blowing up the concurrent production of fine art and consumer objects to an even greater scale for a marketplace that increasingly didn't discriminate between the high and the low. Crucially, it was Murakami who came to define a theory of the Superflat, in which an old master painting and the latest expressions of otaku hypebeasts, as well as most anything in-between, exist upon the same plane. Indeed, much as Murakami helped codify and bring these ideas to the art world, they too were already part youth culture in Japan, which KAWS would experience himself beginning with his first trips there in the late 1990s (a seismic event in KAWS's life that has been so important to

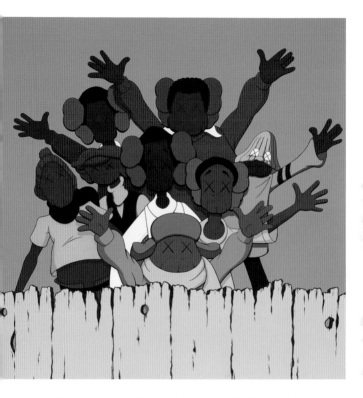

his creative development that we will return to it in a later chapter).

As a collector and connoisseur of rare acumen, there is hardly a limit to what KAWS knows about and takes creative sustenance from. Doing so much to financially support and promote the work of artists he admires and who may not yet have reached his level of popular renown, most discretely KAWS is assembling an

UNTITLED (FATAL GROUP), 2004, acrylic on canvas, 68 × 68 inches (172.7 × 172.7 cm)

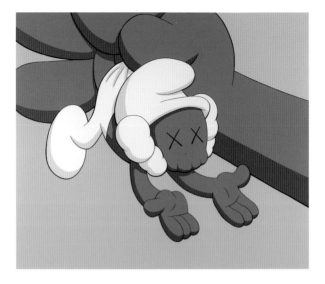

alternative history of such prescient relevance that it may someday rewrite art history as we know it. It would be difficult indeed to overemphasize the sum of his historical recovery: from the important figures of Japanese pop (such as Tadanori Yokoo and Keiichi Tanaami, who remain less known in the West) to the first generations of American graffiti artists (those who emerged on New York subways and, despite their cultural importance, have largely been neglected by museum curators). Such a list includes so many undervalued geniuses (Peter Saul, for instance) and significant movements (including San Francisco's funk scene; Chicago's Hairy Who; and New York's downtown art scene of the late 1970s and early '80s), which constitute only a fraction of his artistic pantheon.

UNTITLED (KURF), 2008, acrylic on canvas,
50 × 60 inches (127 × 152.4 cm)

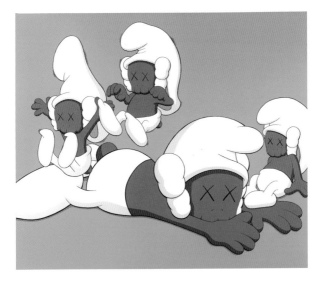

If to some extent we all come to embody what we consume, much of what makes an artist great is how well they process their influences. KAWS, a voracious consumer of art from unexpected and overlooked cultural zones, chews his food very well. So well, in fact, that even his most overt references remain entirely within his own tightly structured vision. To this we might add that while most really good artists have a fantastic and deeply personal understanding of art history, KAWS—long involved in the skateboard, design, graffiti, and street art cultures of the 1980s and '90s—has distinguished himself through his equal knowledge of so much that lies beyond the art historical canon, allowing him to speak to young people around the world in ways that few artists ever have before.

UNTITLED (KURFS), 2008, acrylic on canvas, 50 × 60 inches (127 × 152.4 cm)

IN THE ELEMENTS, 2009, acrylic on canvas, eight parts,
70 × 158 inches (177.8 × 401.3 cm)

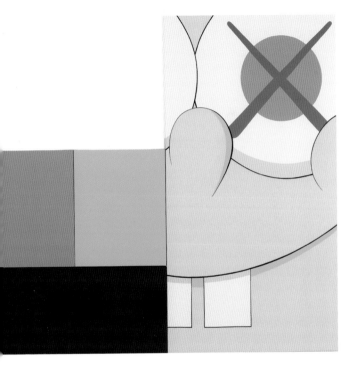

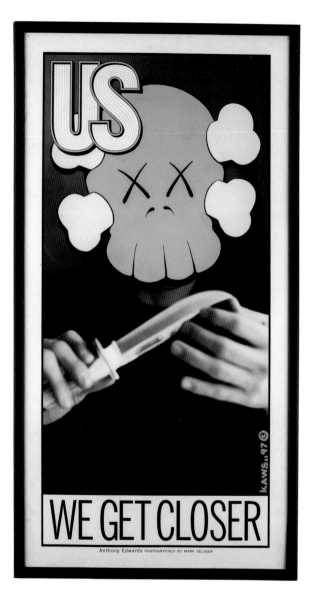

UNTITLED (US), 1997, acrylic on existing advertising poster,
50 × 26 inches (127 × 66 cm)

THE URBAN LANDSCAPE

To say that KAWS began his career as a graffiti artist does not say enough about how roots such as these, born of criminal trespass and iconoclasm, forever shape the mindset and creative language of most every artist who transitions from graffiti to more traditional artistic mediums and genres. Developed early on, the name KAWS and the accompanying artistic persona are the first recognizable creative act that would come to define Donnelly as artist. Neither acronym, nickname, nor coded message, "KAWS" exists as a set of stylistic and phonetic decisions made regarding how a set of letters might look and sound. That's right—for anyone who has puzzled over what "KAWS" might mean, here it is: It comes about as a design decision, one regarding an optimal combination of letters. (Put more simply, not only does it look good, but it sounds good too.)

It's worth considering what goes into a name. Next, consider the development of a specific visual language or logo designed to represent that name; this is the primary exercise of branding, utilized by small businesses and multinational corporations alike. Furthermore, the way a graffiti writer distills their name or tag down to a readily reproducible, pictorially consistent, and easily recognizable pictogram—all requisites to the attainment of a certain kind of fame endemic to this subculture—is the very process of saturation and

recognition fundamental to marketing. In this way, all graffiti artists have an innate understanding of branding, and an awareness of themselves as a brand that has suited many as they move from their criminalized endeavors into myriad other (more socially acceptable) pursuits, where these same skills applied differently are the key to success.

Beginning in the 1990s, the task of so-called "getting up" (which is to say, getting your name up, as on a wall) went vertical, as writers increasingly sought to put their work up on more elevated, gravitationally risky locations to increase the visibility of their art from greater distances, and make it harder to paint over or buff out. It was effective, and to this day you can still see early KAWS graffiti works remaining on the tops of buildings in New Jersey. A direct result of this growing impulse signaled a dramatic change in KAWS's methodology, starting in 1993, when he chose some of the tallest and most visible sites available: billboards. In the process of working on the billboards KAWS began to develop a sophisticated set of visual strategies in which his art began to interact with the imagery within the advertisements themselves. The idea of subverting billboard ads (a practice known as subvertising), had been gaining traction in the politically charged fringes of postgraffiti for some time—as is evident in the interventions of the San Francisco-based group Billboard Liberation Front and prolific in the works of New York-

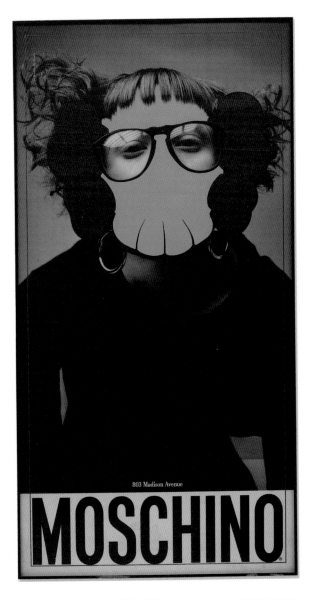

UNTITLED (MOSCHINO), 1997, acrylic on existing advertising poster,
50 × 24 inches (127.8 × 60.8 cm)

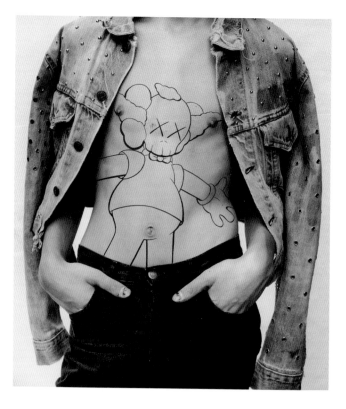

based artist Ron English—and KAWS proved ready to take it to the next level.

This move occurred at a crucial moment, beginning with his early billboard works and quickly ratcheting up when the San Francisco-based graffiti artist Barry McGee (a.k.a. Twist) gifted KAWS a commercial master key used for locking and unlocking the nearly ubiquitous advertising cases in bus stops and on phone booths. At the

UNTITLED, 2001, in collaboration with David Sims, acrylic on photograph, 16 × 12 inches (40.6 × 30.5 cm)

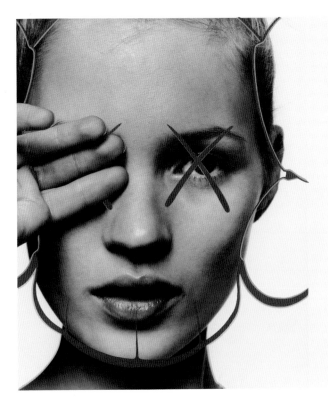

time, cultural attitudes of graffiti art were just begin-
ning to shift. In many ways graffiti developed as an
urban art form during the second half of the twen-
tieth century, a time when inner-city youths were
stranded in their crumbling, abandoned neighbor-
hoods without much present opportunity or future
possibilities. Forgotten, ignored, and largely without
much identity, the old-school practitioners of graffiti
were reclaiming self and place in terms of making

UNTITLED, 2001, in collaboration with David Sims,
acrylic on photograph, 16 × 12 inches (40.6 × 30.5 cm)

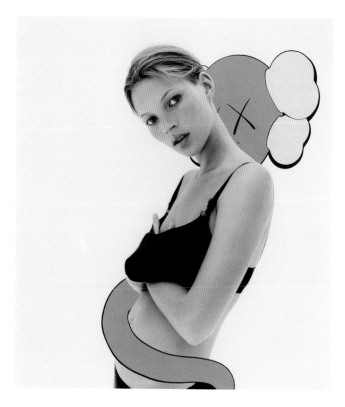

visible and proclaiming who and where they were. As cities changed, undergoing rapid gentrification, a major influx of new money, and a rise in consumerist lifestyle, the urban landscape shifted from a gray zone of vacancy and decrepitude to a busy buzz of commercial come-ons.

Even while so many had fled the cities for the greener, safer pastures of suburbia and a huge portion of the

UNTITLED, 2001, in collaboration with David Sims, acrylic on photograph, 16 × 12 inches (40.6 × 30.5 cm)

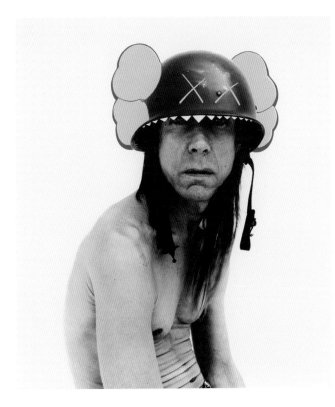

population was too terrified by the crime and grime to even visit, over the 1960s, '70s, and '80s, the young denizens of these places at least had them to themselves. By the end of the century however, their entire visual landscape was co-opted by external forces hell-bent on selling something. It was a huge disconnect: the same people who were so upset about the graffiti on the streets and subways seemingly didn't mind a mass privatization of public space that covered

UNTITLED, 2001, in collaboration with David Sims,
acrylic on photograph, 16 × 12 inches (40.6 × 30.5 cm)

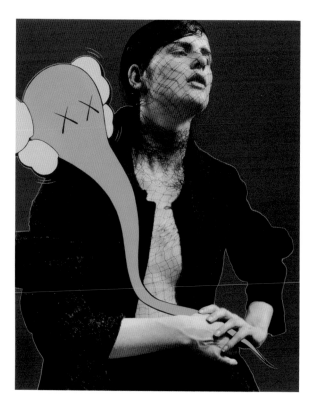

those same subways and streets with a shrill cho-
rus of coercive, commercial advertisements. Artists
thought about this quite differently. The city was their
home, their playground, and the intrusion of an end-
less, constantly spieling and selling marketing machine
felt much more like an invading corporate army. While
many graffiti artists turned to more extreme gestures
of defacement, KAWS turned his attention to infiltrat-
ing the language and strategies of the adscape itself.

UNTITLED, 2001, in collaboration with David Sims,
acrylic on photograph, 16 × 12 inches (40.6 × 30.5 cm)

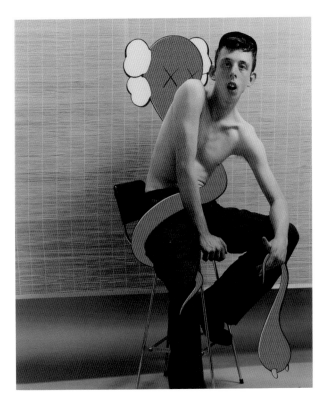

Beginning in 1996 and for a prolific period of six heady years, KAWS abandoned his career as a graffiti writer and focused on a body of work in which he removed ads from bus stops, took them back to his studio to work on, and returned them to their commercial kiosks, subtly, but radically altered. This is the work that first made KAWS famous, and looking back on those that survive (many were stolen and saved by a growing legion of fans) it is easy to see the miraculous impact

UNTITLED, 2001, in collaboration with David Sims, acrylic on photograph, 16 × 12 inches (40.6 × 30.5 cm)

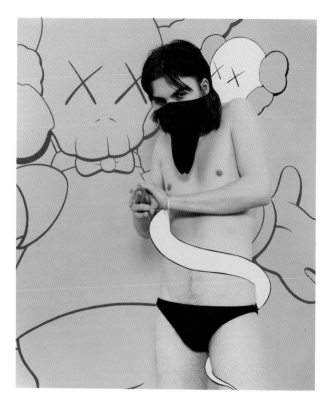

their first appearance heralded within the cityscape. Here KAWS would develop a new technique, learned from his days as an animator, of using acrylic paints to produce a flat, seamless reproductive surface that was nearly indistinguishable from the look of the ads he painted upon. It was hard to distinguish the original image from KAWS's mediation of them, except of course that KAWS was fanciful and ironic in ways that ad agencies would never think of. By focusing

UNTITLED, 2001, in collaboration with David Sims, acrylic on photograph, 16 × 12 inches (40.6 × 30.5 cm)

his attentions on those fashion ads most deeply invested in the objectification and exploitation of youth and gender, he brought a critique to the very industry his art was appropriating. And, by riffing on the imagery already in the ads with his own sly fantasies, KAWS would start to develop both the iconography and the brand-like mimicry evident in his art today.

UNTITLED, 2001, in collaboration with David Sims, acrylic on photograph, 16 × 12 inches (40.6 × 30.5 cm)

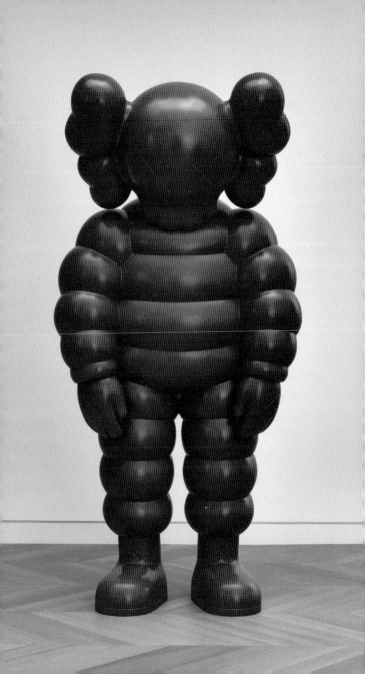

STRANGELY FAMILIAR

Throughout the late 1990s, as KAWS waged his guerrilla campaign of subvertising on the bus stop shelters and phone booths of New York City, he began to develop his own mutant pictography of recognizable but awry iconography. Over the decades to follow, these early adventures in visual branding would continue to evolve and multiply into a distinctive set of recurring characters and anatomical modifications over the decades to follow. Among the first was a coiling, sperm-like snake form that would deftly move through the pictorial space, often wrapping around the models in the ads—a reptilian metaphor for patriarchal desire, capitalism, and the male gaze. It began to suggest an emotional geometry he would continue to explore in his later work. Soon, however, this serpentine form would lose its tail and retain only its head—a minimalist, comic-art-like representation of a skull and crossbones insignia with a simple "X" for each eye. It would quickly become his most iconic image and, transplanted onto the body of the Michelin Man—the corporate mascot created by French cartoonist Marius Rossillon—would constitute the most recognizable body part of KAWS's popular character: CHUM.

WHAT PARTY, 2020, bronze, paint, 90 x 43 x 35 inches (228.6 x 109.2 x 88.9 cm)

Soon after, KAWS streamlined CHUM's billowing body, which was originally intended by Rossillon to suggest a human form made out of stacked automobile tires. This move gave CHUM a less heroic figuration, and lent an endearingly awkward and self-conscious posture, which in turn led to KAWS's most popular figure: COMPANION. If CHUM was somehow mighty and muscular, like a misfit superhero, COMPANION spoke to an easily identifiable emotional frailty: insecurity. KAWS continues to modify and manipulate his existing characters, subjecting COMPANION, for instance, to comically gory anatomical cross sections to reveal internal viscera, and frequently posing COMPANION in a see-no-evil gesture of covering his face with his hands, which can be alternately coy—frozen in a childish game of peekaboo—or a pose driven by some unnamed, grief-stricken denial. Next there is the addition of a new persona: ACCOMPLICE. Building on many of COMPANION's attributes, which cleverly reference Walt Disney's culturally ubiquitous Mickey Mouse, ACCOMPLICE is a creature of KAWS's own imagination, complete with pointy bunny ears, at once adorable and utterly alien.

Having established his signature representational tropes, KAWS has conquered the universe of received signs with his own deviant impersonations, reimagining some of pop culture's most beloved personalities in his uniquely universalizing and idiosyncratic style. Among the greatest of his revisionist

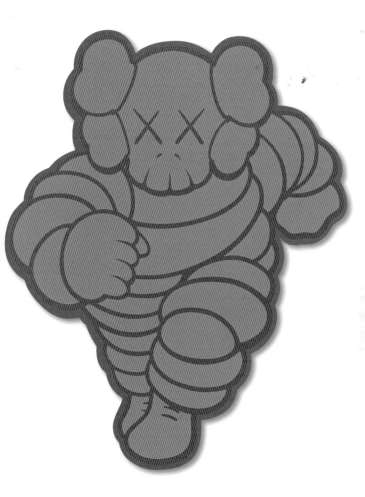

CHUM (KCC3), 2014, acrylic on canvas over panel,
84 x 68 inches (213.4 x 172.7 cm)

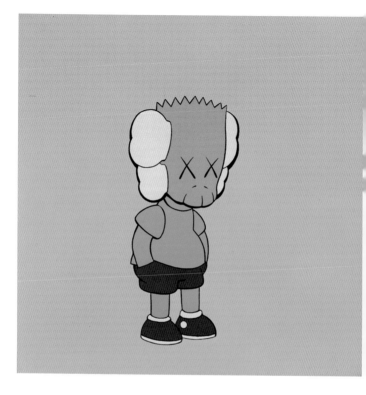

hits over the years have been his revisions of popular cartoon characters from *SpongeBob SquarePants*, *The Smurfs*, and *The Simpsons*, translated in KAWS's dramatis personae as: KAWSBOB, KURFS, and KIMPSONS. What all of KAWS's personages have in common, from COMPANION to his re-interpretations of classic figures, from *Star Wars* stormtroopers to Pinocchio, is precisely the facility to articulate what we all have in common, be it the

KIMPSONS SERIES, 2005, acrylic on canvas, 8 x 8 inches (20.3 x 20.3 cm)

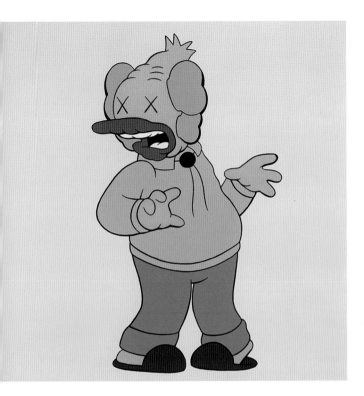

common language of cartoon characters or the commonality of complex emotions we all share, even if we find such states difficult to articulate. This is the insidious, populist force KAWS has mastered: The ability to speak to what we all feel in ways that we all know. And, to do so in a generous spirit of sharing, where empathy and identification lead us to a deeply personal mode of understanding.

KIMPSONS SERIES, 2005, acrylic on canvas, 8 x 8 inches (20.3 x 20.3 cm)

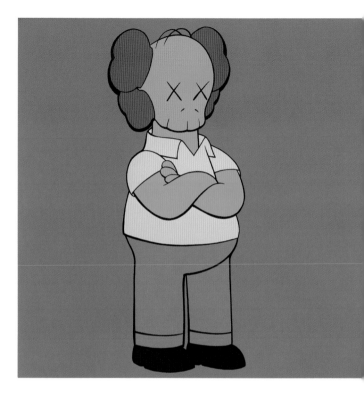

KIMPSONS SERIES, 2005, acrylic on canvas,
8 x 8 inches (20.3 x 20.3 cm)

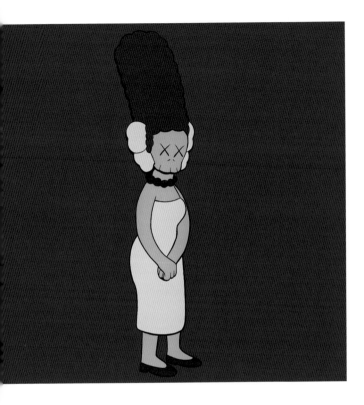

KIMPSONS SERIES, 2005, acrylic on canvasl,
8 x 8 inches (20.3 x 20.3 cm)

NO EXIT, 2020, acrylic on canvas,
98 x 104 inches (248.9 x 264.2 cm)

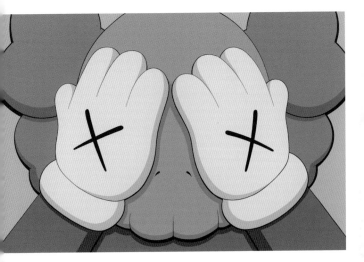

UNTITLED (COMPANION CLOSE UP, GREY), 2013,
acrylic on canvas, 48 × 72 inches (121.9 × 182.9 cm)

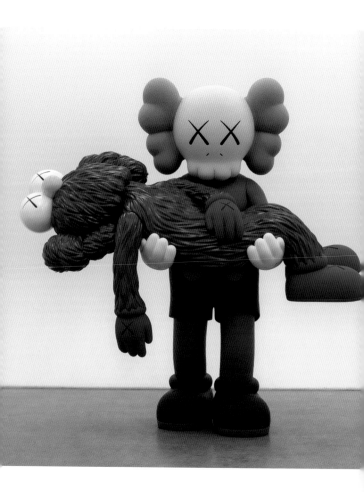

GONE, 2018, bronze, paint,
71 × 71¹/₂ × 29³/₄ inches (180.3 × 181.6 × 75.6 cm)

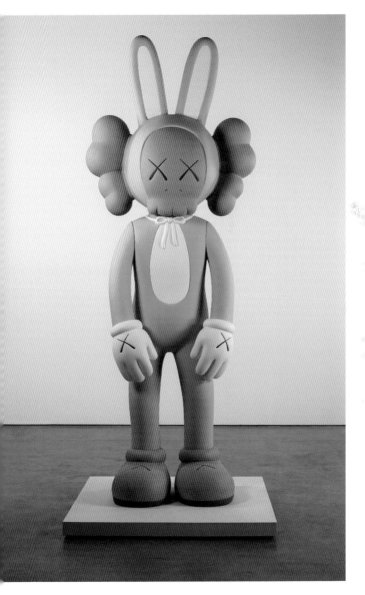

ACCOMPLICE, 2010, fiberglass, paint,
120 × 47^1/$_2$ × 36 inches (304.8 × 120.65 × 91.44 cm)

COMPANION (RESTING PLACE), 2013, aluminum, paint,
60$\frac{1}{2}$ × 63 × 80 inches (153.67 × 160 × 203.2 cm)

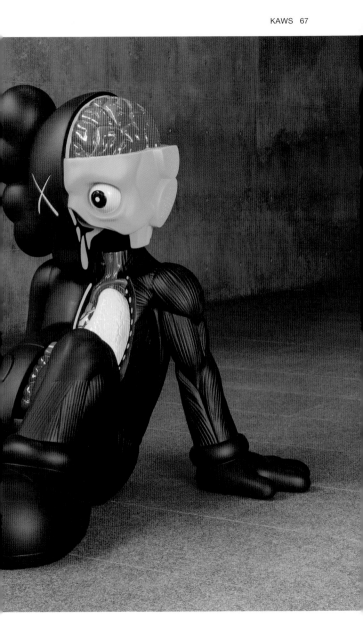

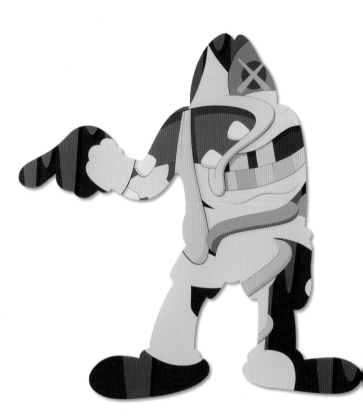

POINT OF DISORDER, 2013, acrylic on canvas,
120 × 116 inches (304.8 × 294.6 cm)

MIX CULTURE

To understand the how and why of KAWS's ravenous reaping and cunning mediation of visual information, it's helpful to think of sampling in music, where preexisting recordings—chosen for their particular sounds, percussive patterns, and melodic fragments—are extracted and woven into new audio compositions. This borrowing something old to something make new (an irony conjured in KAWS's brand name OriginalFake), is the technique developed within the urban DJ culture KAWS experienced in New York City. It is a technique used to create seemingly endless, fugue-like mixes designed to keep the dance floor rocking, and is at the foundation of the hip-hop culture that has become the soundtrack for our times. It is also one of the most locatable and recognizable manifestations of postmodernism, the contemporary sensibility that emerged after modernism's insistence on the new as the basis for authenticity and originality, whereby appropriation and alteration are considered equivalent to outright invention.

KAWS enters into the postmodern flux as a condition a priori, an awareness his generation inherits like an extra vertebrae already evolved into the cultural anatomy, akin to the way that those born into the digital age display a seemingly natural technological savvy. Like many of his peers, KAWS is part of a cultural shift in which the capitalist disease of consumer-driven conspicuous consumption is no

PERILS, 2008, acrylic on canvas,
68 × 86 inches (172.7 × 218.4 cm)

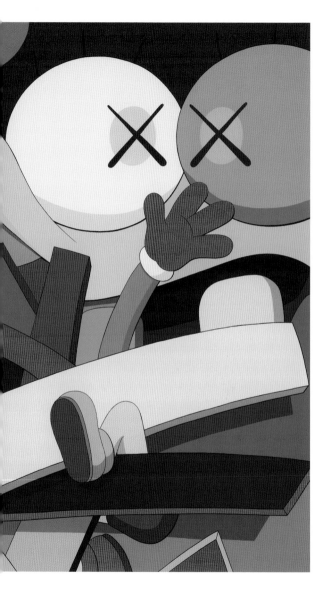

longer viewed with unease. This broad inheritance of the postmodern condition has meant that KAWS and his peers didn't have to swallow it like a bitter, theory-laden pill. Rather, their willingness to dive into this continuous stream of fluidity and hybridism with an easy acceptance has been read by the bastions of aesthetic and ideological purity as a kind of base

CAUGHT IN THE CURRENT, 2013, acrylic on canvas, eighteen parts. Each part: 40 inches diameter (101.6 cm diameter)

acquiescence, lacking in critically or critique. On the contrary, to navigate the slippery slope and diffuse scope of KAWS's grand mash-up is to contend directly with the high level of irony and critical distance from which twenty-first-century consumer connoisseurs regard the algorithmic flux of desire and meaning contained within the marketplace.

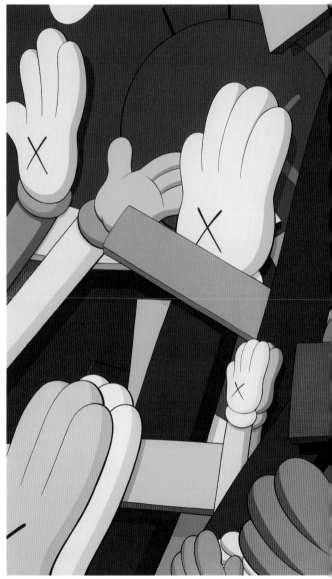

CURTAINS, 2008, acrylic on canvas,
68 × 86 inches (172.7 × 218.4 cm)

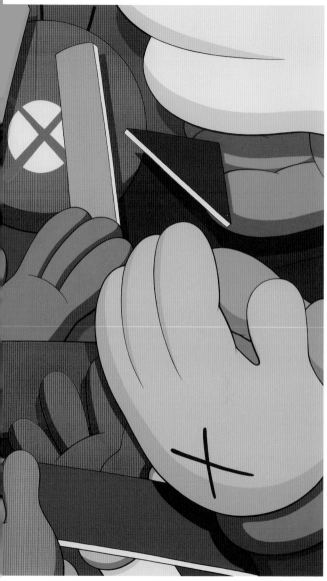

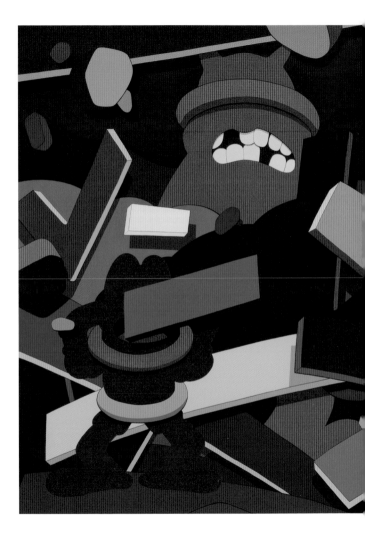

GATEKEEPERS, 2009, acrylic on canvas,
86 × 136 inches (218.4 × 345.4 cm)

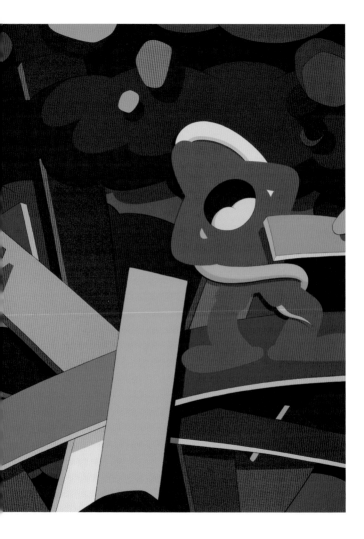

If, from the start, KAWS is fully versed in the array of conjunctions, disjunctions, juxtapositions, and distortions wrought by our pandemic globalism, this is not to say that he is born with the same level of knowledge and understanding when it comes to the craft and history of painting. Like all emerging artists, he has had to learn and find his own way to integrate this within his practice. This expanding awareness of the stylistic and compositional innovations delivered over a century of modernism's epic investigation of novelty has been among the most exciting aspects of his creative development, and this superstructure has sustained his evolution far beyond the faddish success surrounding his early work. Soliciting an amalgamate sensibility of compound cultures colliding and fusing as if all thrown into a blender, the ways in which twentieth-century avant-garde artists broke down and scrambled visual information has provided KAWS a formalist floor plan for his increasingly abstract and recombinant architecture of disarrayed references. To fully iterate all the ways in which KAWS has absorbed the different lessons of cubism, futurism, pointillism, gestural abstraction, or pattern and decoration (to name but a few) would make for a very long and ultimately very boring book; but for an abberviated reading of the many ways he has employed these strategies, one need only compare the visual liberties KAWS took with his Peanuts and Joe Cool paintings.

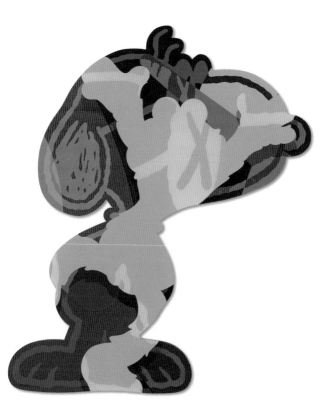

FIVE SUSPECTS (#ONE), 2016, acrylic on canvas,
84 x 73 inches (213.4 x 185.4 cm)

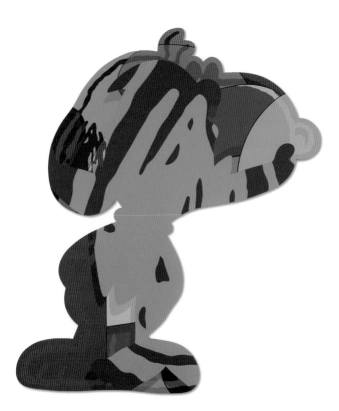

FIVE SUSPECTS (#TWO), 2016, acrylic on canvas,
84 x 73 inches (213.4 x 185.4 cm)

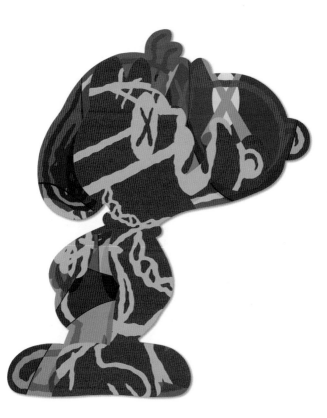

FIVE SUSPECTS (#THREE), 2016, acrylic on canvas,
84 x 73 inches (213.4 x 185.4 cm)

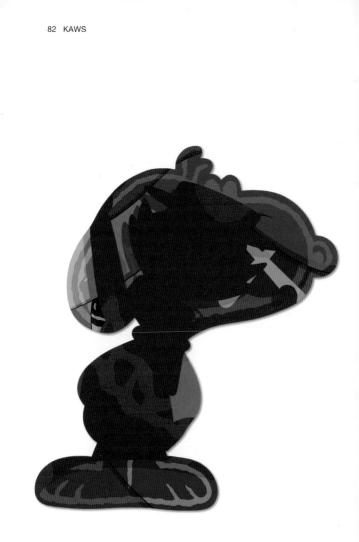

FIVE SUSPECTS (#FOUR), 2016, acrylic on canvas,
84 x 73 inches (213.4 x 185.4 cm)

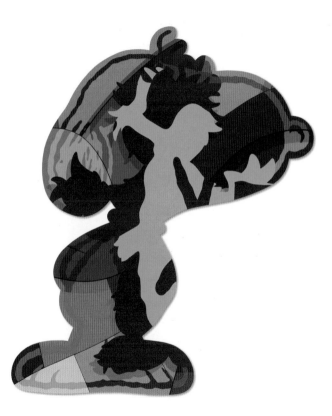

FIVE SUSPECTS (#FIVE), 2016, acrylic on canvas,
84 x 73 inches (213.4 x 185.4 cm)

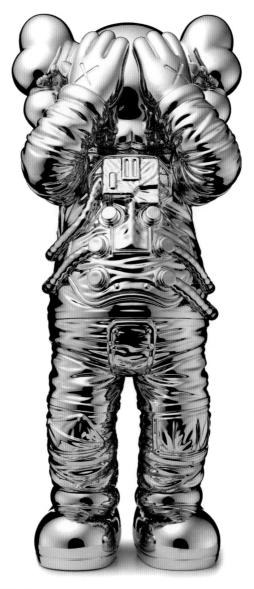

HOLIDAY SPACE, 2020, vinyl, paint,
$11^5/_8$ x $5^1/_4$ x $4^1/_2$ inches (29.5 x 13 x 11.4 cm)

CONSUMER AESTHETICS

I wrote for a book on KAWS once before, but no one read it. Maybe it wasn't any good. It was so long ago I can't remember, but that's not the reason it went unread. KAWS designed it to pair with the package paintings he was making at the time— small paintings encased in the style of packaging that a small toy or similar collectible might come in. No one read the book, or even knew that I had written something in it, because to take it out of the packaging would be to immediately sacrifice the object's value; that is, the unified whole of product and packaging would no longer be mint, that condition of untouched perfection so valued by collectors. I'd like to read what I wrote someday but I probably never will. The book is worth so much money now that I could never afford it.

As strange as this is to consider—a book too precious to enjoy; an object in which the packaging is integral to the contents in such a way that to access one is to compromise the other's integrity—it's a valuable lesson on the nature of value, one that KAWS was already teaching back then. We're used to a high degree of preciousness in the world of painting, the exceptional worth of the artist's hand in creation, the great rarity of a work as something utterly unique, and the extraordinary prize it represents to own such a thing. But KAWS flipped the script to show us how these notions

of scarcity and exclusivity can be manifest and magnified in the realm of serial production, limited editions, and packaging design. And when you think about how much his old, soft vinyl figurines are selling for now, he sure knew what he was talking about.

KAWS's mimicries and ironies—at once playful provocations, partial parodies, and philosophical inquiries into the broader phenomenology—contort and complicate the prevailing media, commercial, and consumer paradigms of today. A consumer himself, who cares as much about what he wears on his feet as he does about what he hangs on his walls (as do many of us), KAWS is not so much ridiculing our psychological relationship to the material world as he is devising ingenious surrogates for our animistic attachments, excavating and expressing just what it is about all the stuff in our closets and store windows that we care about. These are emotional attributes, ascribed to the inanimate, written in the semiotics of capitalist luxury, and fulfilled in the more fully emotive spectrum of fine art—altogether an enfolded and unfolding experience where customer, user, and spectator are enriched across a matrix of brand identity, individual selectivity, and social signification. Is this a genuine experience or a simulacrum? A unique, sacred object or a product of false idolatry? For KAWS and those who purchase his hybrid admixture of merchandise and meaning, this is the original fake, a tangible truth woven into the fabric of our falsity.

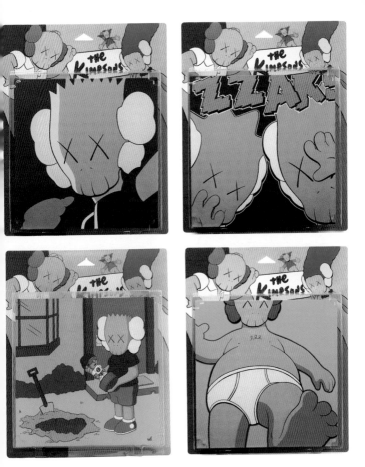

OriginalFake—KAWS's brand of limited edition wares started in Japan and further established in 2006 as a retail shop in Tokyo—is something like a specialized label within the bigger brand identity that is KAWS himself. What he produces belongs to a lineage of art

UNTITLED (KIMPSONS), PACKAGE PAINTING SERIES, 2001/2004, acrylic on canvas in blister package with printed card, 23 1/2 x 19 inches (59.7 x 48.3 cm)

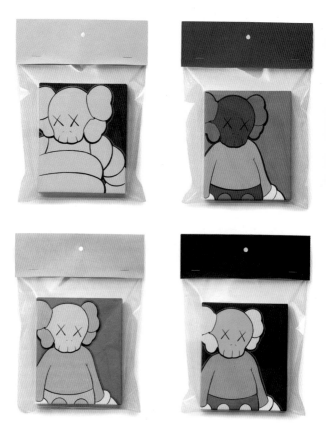

objects that arose in the 1950s and '60s. Inspired by the possibilities of Duchamp's readymades, artists began to experiment in a form that could at once be produced in multiple and yet remain conceptually an original. As a medium for KAWS's populist idea of art, they represent both an undermining of the art-world fetish for the priceless one of a kind and an expansion of its audience through a deliberate

UNTITLED (ORIGINAL FAKE SERIES), 2002, acrylic on canvas in plastic bag with hang tag, 6 x 5 inches (15.2 x 12.7 cm)

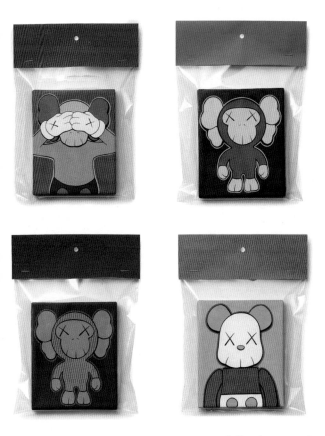

strategy of affordability and accessibility. As a vessel able to contain the dynamics of mass manufacture while maintaining the essence of being an original rather than a copy, KAWS's vinyl figurines—issued in varying sizes, poses, and colors, and featuring his most iconic characters—are the consummate multiples, but in a way most every commercial object he puts his hand to is.

There could be no surer sign of the strength of KAWS as a brand than his ability to constantly change up the medium, style, and form of his popular products with the same kind of experimental risk that our more adventurous artists do in migrating through these changing terms. What is more, his visual language remains so recognizable and capable of retaining its identity that it is able to cross-pollinate with other brands of equally formidable associations without ever compromising his own vision. This process of an artists working with well-established, internationally trademarked companies is not unique to KAWS; co-branding has been going on for a number of years, and increasingly so as couture fashion houses and multinational apparel brands seek to tap into the markets that these artists represent. What is different, perhaps, is that unlike the individual artist, KAWS has established himself as a brand with a distinct identity, one that must be presented and protected with the same caution and care as any other valuable and immutable franchise identification.

Considering the wide range of corporate collaborations KAWS has undertaken over the years, working with some of those most universally esteemed brands and designers (including, but not limited to, Comme des Garçons, Levi's, Marc Jacobs, Nike, Dior, and Supreme), it is remarkable the degree to which he is able to adapt his vision to the visual identity of others in such a way as to keep it all within his abiding KAWSmology, while also enjoying the creative synergy and exponen-

tially magnified reach of these household names. This is not to mention all the cool collaborations he does with more underground and niche brands, nor the many he has worked with directly in Japan, which have been so foundational to his artistic development that we will look at them more closely in the next and final chapter.

SMALL KM LANDSCAPE, 2001, acrylic on canvas, 48 x 48 (121.9 x 121.9)

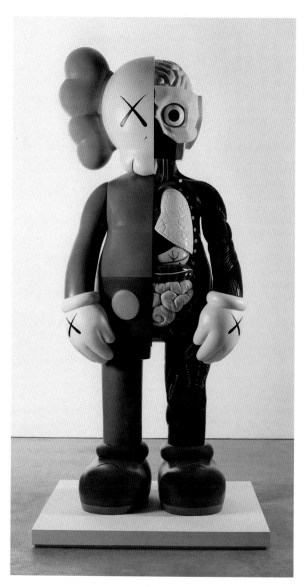

WHY KAWS MATTERS

It is a bit odd ending a book on KAWS with a question of his significance — perhaps unnecessary, like preaching to the choir, to do so for people who have bothered to get this publication into their hands and read it so far. But for all his millions of fans, KAWS remains still a controversial figure within the art world establishment. Call it the taste of sour grapes, but his art and success are not without their critics. Even if we don't need to convince you, and the elites who act like gatekeepers of taste and value are small enough in number that you will likely never meet one, consider that when someone puts down KAWS's work what they are really doing is dismissing his legion of admirers for somehow lacking the connoisseurship and intelligence to know better. For such occasions it is important to know why we like his work, to know why it matters.

ORIGINALFAKE COMPANION, 2006, painted fiberglass, $118^{1}/_{4}$ x $54^{1}/_{3}$ x $35^{7}/_{16}$ inches (300 x 138 x 190 cm)

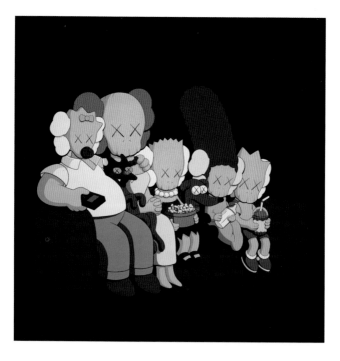

To understand how work, where the abiding question might be, what's not to like? has garnered such opprobrium from people who are ostensibly art lovers, we need to consider the context. On the pettiest level, we must contend with the fact that collectors, curators, critics, and the like are heavily invested in being the ones discovering new things, so that when an artist lands in the art world by popular demand, arriving with legions of fans and an immeasurable level of success to a discipline that has largely never heard of them before, it upsets the consensus structure by which art is gradually ratified up the ranks. In such cases the re-

UNTITLED (KIMPSONS), 2004, acrylic on canvas, 80 x 80 inches (203.2 x 203.2 cm)

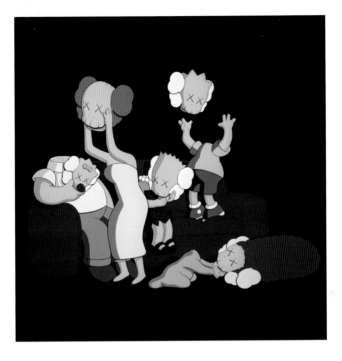

active instinct is to deem the art too commercial, too populist for their refined palates. This not only ignores the fact that so many of the greatest artists in the canon enjoyed tremendous success and popularity in their own lifetimes, it obviates the history of postwar art where figures like Andy Warhol and Keith Haring (both of whom are inspirations for KAWS) endeavored to break down the hierarchical lines between commercial and fine art. KAWS is not great because he is popular, but his greatness is vested in his keen understanding of how communication in the broadest possible sense to the most inclusive audience actually works.

UNTITLED (KIMPSONS #2), 2008, acrylic on canvas, 80 × 80 inches (203.2 × 203.2 cm)

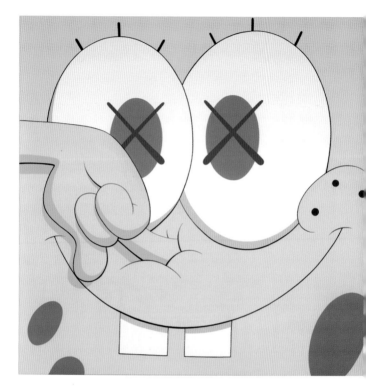

It is in this remarkable facility KAWS has to reach people, to touch them in ways that a lot of highbrow, exclusive art simply cannot, that we can locate his unique gifts. Unlike many of his contemporaries—though he is not alone— KAWS doesn't parlay in obscure insider references directed at a cultured few; his art seeks a common visual language that is recognizable and readable to all. By high-

I CAN'T FEEL MY FACE, 2008, acrylic on canvas, 68 x 68 inches (172.7 x 172.7 cm)

jacking (or in art-speak, appropriating) the familiar, he takes his ever-expanding cast of universally beloved figures from commercial, comic, and cartoon sources out of their typical storylines and transposes them into compositionally complex and pictorially stunning Pop representations where, most importantly, narrative specificity is secondary to open-ended interpretation, allowing

TARGET GAMES, 2009, acrylic on canvas,
96 x 72 inches (243.8 x 182.9 cm)

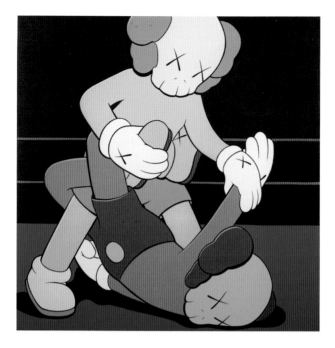

everyone the opportunity to imagine their own way of understanding them. His mediation of the known—be it the X eyes, the patterning within figures, the anatomical exposing of viscera, or the cropping and recombination of gestural details—at once abstracts the originals while heightening their emotional impact.

It is in fact the emotional richness of KAWS's art that people are really responding to, far more than the various characters that act as containers for this psychological depth. His paintings and sculptures allow each of us to access and explore feelings and issues that we

UNTITLED (S.V.D.M.), 2002, acrylic on canvas,
16 × 16 inches (40.6 × 40.6 cm)

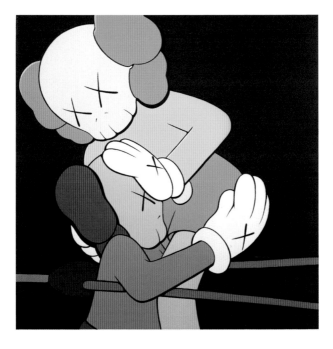

rarely share with others and often suppress within our-
selves—confusion, panic, joy, pleasure, fear, fun, mor-
tality, loneliness, vulnerability and love, to name but a
few—that continue to move us in ways that the best art
is capable of. If KAWS is about all these mixed emo-
tions, his art is about something even greater and ex-
ceptionally rare in our world today: empathy. Art has
many missions and serves different people in different
ways, but when it works for all of us it does so by find-
ing a common ground in the human condition where
we can see and feel as others do, to share what really
matters across all our differences.

UNTITLED (S.V.D.M.), 2002, acrylic on canvas,
16 × 16 inches (40.6 × 40.6 cm)

Photography Credits

Farzad Owrang: 11, 14–15, 24–25, 28, 57, 62, 79, 80, 81, 82, 83

Tom Powel Imaging Inc.: 12–13, 18–19, 22, 46, 47, 48, 49, 50, 51, 52, 53, 68, 72–73

Peter Harholdt: 17

AllRightsReserved, Ltd.: 20–21

Brad Bridgers: 27, 84, 87, 88–89

Fuminari Yoshisugu: 42

Michael Biondo: 54

Jonty Wilde: 65, 92

Todora Photography: 66–67

KAWS (Brian Donnelly)

KAWS (Brian Donnelly) engages audiences beyond the museums and galleries in which he regularly exhibits. His prolific body of work straddles the worlds of art and design to include paintings, murals, graphic and product design, street art, and large-scale sculptures. Over the last two decades KAWS has built a successful career with work that consistently shows his formal agility as an artist, as well as his underlying wit, irreverence, and affection for our times. His refined graphic language revitalizes figuration with both big, bold gestures and playful intricacies. As seen in his collaborations with global brands, KAWS's imagery possesses a sophisticated humor and reveals a thoughtful interplay with consumer products. With their broad appeal, KAWS's artworks are highly sought-after by collectors inside and outside of the art world, establishing him as a uniquely prominent artist and influence in today's culture.

ACKOWLEDGMENTS

First and foremost, my thanks go to Brian Donnelly, who is the inspiration and basis of this publication. It is an honor to be aligned with such an incredible thinker, creative mind, and artistic leader of the past decade.

My deepest thanks to Carlo McCormick for his authorship and astute insights into the world of KAWS, and to Matthew Christensen for his editorial stewardship. I would also like to acknowledge Dieter Buchhart for his exceptional curation and vision in this area.

I would like to sincerely thank David Arkin, Gen Watanabe, and Mark Barrow at KAWS Studio for their support.

Very special thanks as well to Daisuke Kusakari at Bluesheep for his exceptional design of the Japanese edition of this publication.

My thanks as well to Fiona Graham, Susan Delson, and Karen Lautanen for their editorial support and organization of this publication, to Hannah Alderfer for her extraordinary design work, and to Sarah Sperling, Kevin Wong, Keith Estiler, Rickey Kim, and the entire NMR team for their global support. My sincere thanks as well to Taliesin Thomas for her amazing assistance on this and many other projects, and to Steven Rodríguez and John Pelosi for their continued support.

Finally, I give all my bottomless gratitude to my amazing wife, Abbey, and to my wonderful children, Justin, Ethan, Ellie, and Jonah for their love and encouragement.

As always, I give endless love and thanks to my mother, Judith.

Larry Warsh
New York City
September 2023

LARRY WARSH

LARRY WARSH has been active in the art world for more than thirty years as a publisher and artist-collaborator. An early collector of Keith Haring and Jean-Michel Basquiat, Warsh was a lead organizer for the exhibition *Basquiat: The Unknown Notebooks*, which debuted at the Brooklyn Museum, New York, in 2015, and later traveled to several American museums. He also served as a curatorial consultant on *Keith Haring I Jean-Michel Basquiat: Crossing Lines* for the National Gallery of Victoria. The founder of Museums Magazine, Warsh has been involved in many publishing projects and is the editor of several other titles published by Princeton University Press, including *Basquiat-isms* (2019), *Haring-isms* (2020), *Futura-isms* (2021), *Abloh-isms* (2021), *Arsham-isms* (2021), *Warhol-isms* (2022), *Hirst-isms* (2022), *Pharrell-isms* (2023), *Judy Chicago-isms* (2023), *Holzer-isms* (2024), *Neshat-isms* (2024), *Jean-Michel Basquiat's The Notebooks* (2017), and *Keith Haring: 31 Subway Drawings* (2012), among others. Warsh has served on the board of the Getty Museum Photographs Council, and was a founding member of the Basquiat Authentication Committee until its dissolution in 2012.

NO MORE RULERS

NO MORE RULERS (NMR) is on a mission to rethink the way we define art and creative expression. Based in New York, NMR is a publishing company dedicated to empowering the creative community and questioning the status quo. Our artist publications erase the boundaries between high and low, popular culture and fine art, and between traditional categories like design, music, and fashion. By partnering with global institutions and focusing on topics ranging from contemporary culture to artistic process to creativity, we're creating a world where art can truly be for everyone.

NO MORE RULERS